Sketching and Drawing for Children

SKETCHING AND DRAWING
FOR CHILDREN

Genevieve Vaughan-Jackson

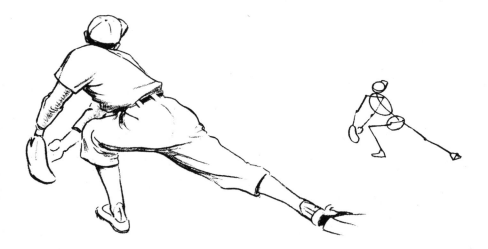

A PERIGEE BOOK

A Perigee Book
Published by The Berkley Publishing Group
A division of Penguin Putnam Inc.
375 Hudson Street
New York, NY 10014

First Perigee edition: June 1990

The Penguin Putnam Inc. World Wide Web site address is
www.penguinputnam.com

Library of Congress Cataloging-in-Publication Data

Vaughan-Jackson, Genevieve.
Sketching and drawing for children / Genevieve Vaughan-Jackson.
p. cm.
Summary: Discusses drawing, perspective, and proportion, and
provides instructions on specific drawing techniques.
1. Drawing—Technique—Juvenile literature. [1. Drawing—Technique.] I. Title.
NC655.V33 1990 89-38548 CIP AC
741.1—dc20
ISBN 0-399-51619-0

Printed in the United States of America
30 29 28 27 26

This book is printed on acid-free paper.
∞

If you have opened this book, it must be because you like to draw and hope that you will find in it ways to draw better. Perhaps you like sketching horses, or cats, or people, or flowers, only sometimes they just do not come out *right*. If this happens, most likely you do not really know and understand what you are trying to draw.

An artist learns to look at things in a different way from most people. He does a lot of work without ever putting a line down on paper. He *looks* at things and trains his eye to see shapes and sizes and proportions, so that when he does pick up a pencil he can be *sure* of what he draws.

Drawing Is

If you want to be able to draw, the first thing you must learn to do is *see*.

For instance, suppose that someone asked you to draw a bicycle. How far would you get before you found you were not quite sure how to do it?

If you are able to draw it, it is because you have really *looked* at a bike and *know how it works*.

You know how the wheels are fastened to the frame, how the handlebars fit, and where the chain is. You can tell how big the wheels are, compared to the whole bike.

Perhaps you want to draw a boy who is running fast. Can you *see* him? Close your eyes and *think* about him. Imagine yourself running, and try to feel what you are doing. What do you do with your arms when you run? Do you bend forward more than when you walk?

To be able to draw the boy running, you must understand how your body works. You must know the framework as well as you know the frame of a bicycle.

This book will help you to know *how things work*. It will tell you how to look at them so that you really *see* them. And it will show you how to *draw* them.

Seeing

FIRST THINGS FIRST

Here are some suggestions about drawing in general to think about and try out before we go on to special things.

1. Use a *soft* pencil, not a hard one. A "B," or a Number 2, is good for most drawings.

2. Hold your pencil steady, but do not grip too hard—it is very tiring.

3. Draw *lightly* at first. Try not to press too hard on your pencil when you begin.

4. Have a *soft* eraser handy. Keep it clean by rubbing it on another piece of paper so that it will not smudge your drawing.

5. Have enough space around you so that you do not feel cramped!

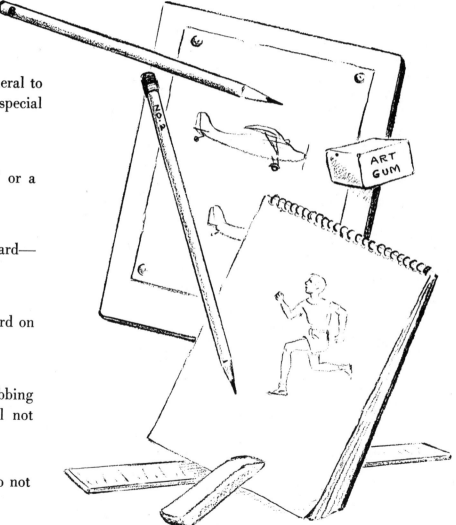

OTHER MATERIALS FOR DRAWING.

Pen and Ink. Sometimes you may want to try pen and ink. Use waterproof black India ink, and you might try to get Hunt or Gillott pen-points, but these are not essential. Pen-points come in different sizes—get some medium and some fine. Use a pencil to show very faintly the position of your sketch, but try to draw with the pen. Do *not* just ink over a pencil drawing! If you go wrong, put another piece of paper over your first one and try again. (Your paper must be fairly thin, of course, so that you can see the first drawing through it.)

Charcoal. You can get charcoal in sticks or pencils. It is *very* black and smudgy, but it is fun to rub in shadows and dark spots with your finger. You need a special charcoal eraser to rub out light patches. It is soft and slightly sticky, and you can squeeze it into fine points if you need to. Press it down on the charcoal and lift it off, at first. Don't try to rub it until most of the charcoal has been picked up, otherwise it will smear badly. You can get a fixative to spray on your drawing when it is finished so that it will not smudge or rub off. A paper that is not too smooth is best for charcoal.

Color. If you feel you must use color in your pictures, use pencil crayons. Do not use paints, for your paper is not suitable and will stretch and bubble. Shade the crayon to go with your lights and shadows.

For any of the special materials mentioned on this page you will probably have to go to an artist's supply store. Some stationery stores will carry them.

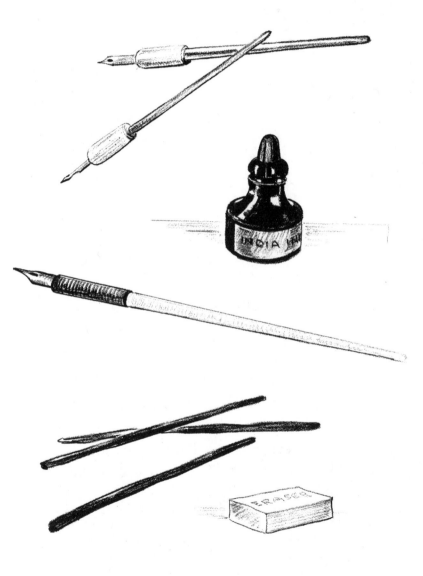

HOW TO GO TO WORK

1. Try to have plenty of space around you! It is hard to draw well if you feel cramped.
2. Draw on a sloping surface, if possible, not flat on a table. If you have a drawing board, put a book under one end to raise it a few inches.
3. Never grip your pencil very tightly. Feel free to move your whole arm as well as your hand and wrist.
4. *Always draw very lightly at first.* Then lines will not be hard to erase.
5. Even in the simplest picture, imagine it on your page before you begin. In this way you are more likely to be able to fit in everything you want. Now let's begin!

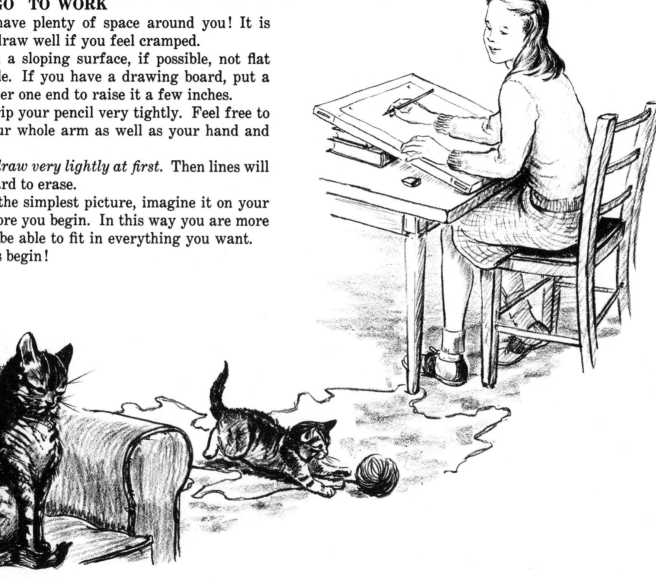

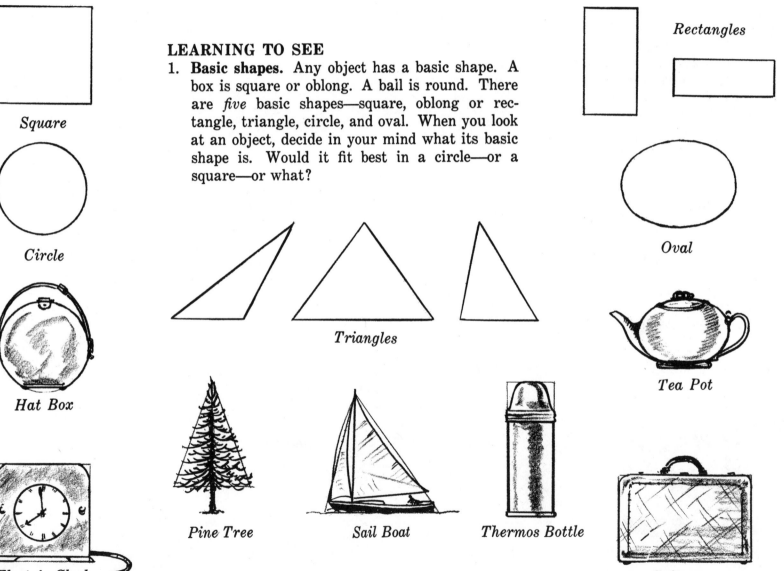

LEARNING TO SEE

1. **Basic shapes.** Any object has a basic shape. A box is square or oblong. A ball is round. There are *five* basic shapes—square, oblong or rectangle, triangle, circle, and oval. When you look at an object, decide in your mind what its basic shape is. Would it fit best in a circle—or a square—or what?

Square

Circle

Hat Box

Electric Clock

Pine Tree

Triangles

Sail Boat

Thermos Bottle

Rectangles

Oval

Tea Pot

Suitcase

Look around your room and see if you can find all the basic shapes. Perhaps some objects are a combination—triangle-and-circle, or rectangle-and-triangle, etc. Try drawing a few, first sketching the basic shape (don't forget—LIGHTLY!) and then fitting the object into it.

GLIDING ON THE PAGE

When you want to draw a line across your page, let your *whole hand and arm* move, like this:

And for upright line, too, slide your whole hand and arm.
Start at the top. RELAX!

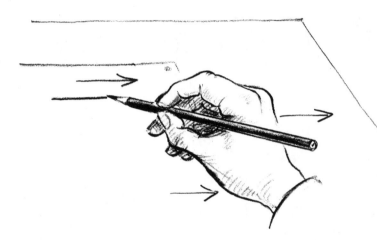

Do you find it hard to draw circles? Try going round and round as though you were stirring a cake.

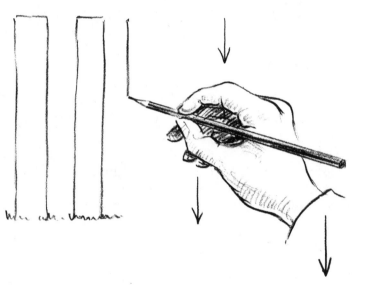

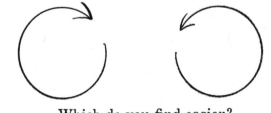

Which do you find easier?

Now try some upright lines, such as a series of fence posts. Start at the top. Again, let your *whole hand and arm move*, downward this time. *Relax!*

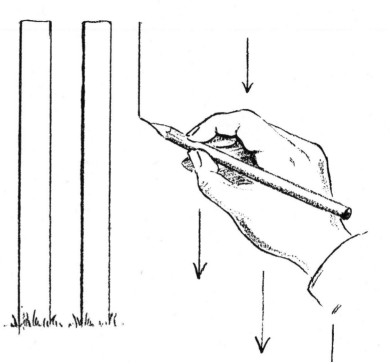

Diagonals

Now try some circles. At first, try going 'round and 'round, as though you were stirring in a bowl. Then see how good a circle you can make at one stroke.

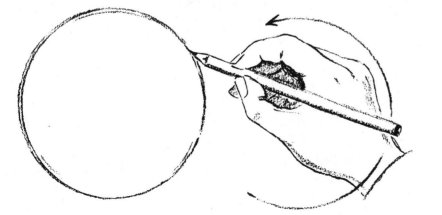

Which do you find easier?

Finding Things

Just for practice, try drawing some familiar things, using straight lines and circles. Draw them large. Draw lightly at first. Then, if you want to erase, you can do it without leaving any smudge marks on your paper.

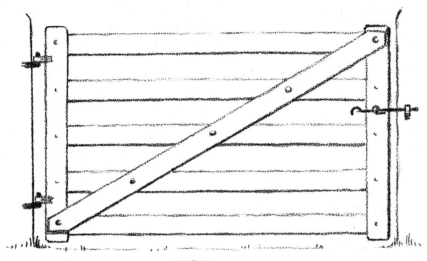

A Gate.

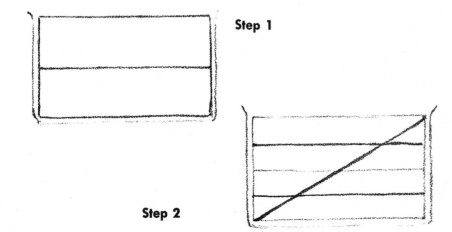

Step 1

Step 2

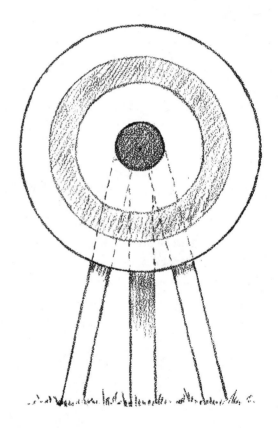

A Target.
Draw the stand first, very lightly. Then fit on the target and erase the part of the stand hidden behind the target.

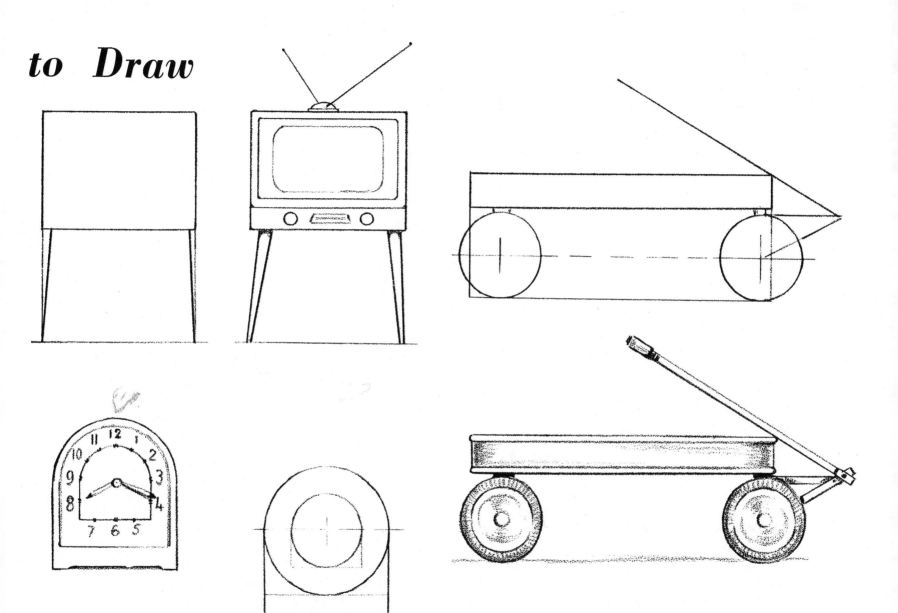

to **Draw**

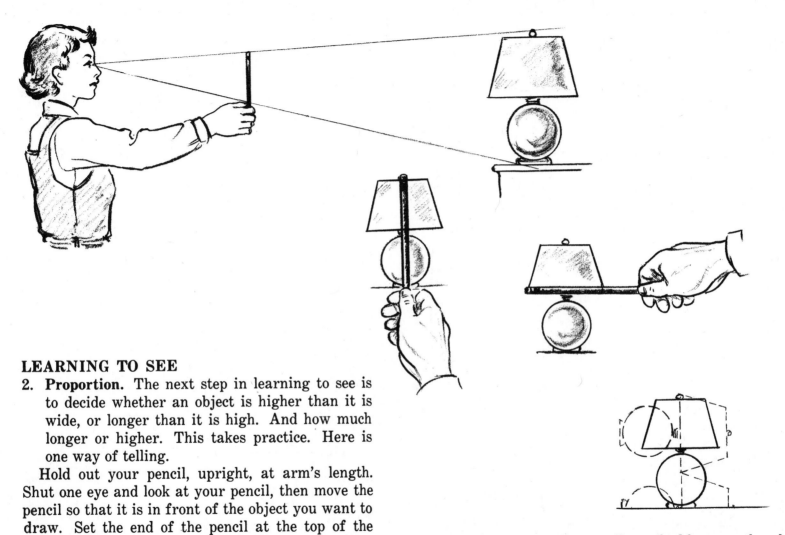

LEARNING TO SEE

2. **Proportion.** The next step in learning to see is to decide whether an object is higher than it is wide, or longer than it is high. And how much longer or higher. This takes practice. Here is one way of telling.

Hold out your pencil, upright, at arm's length. Shut one eye and look at your pencil, then move the pencil so that it is in front of the object you want to draw. Set the end of the pencil at the top of the object, and mark with your thumbnail where the bottom of it seems to come on the pencil. Now, without moving your thumb, turn the pencil horizontally.

Does the space on the pencil, marked by your thumb, overlap the object? Or could you put, say, one and a half, or two pieces of pencil in it?

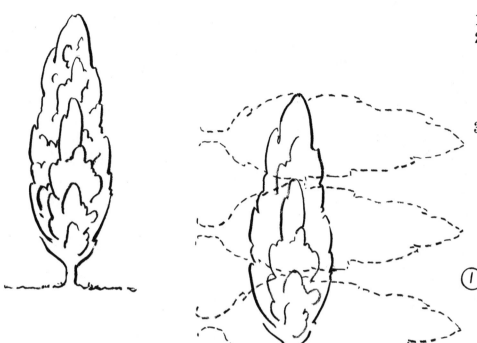

Steps in drawing this tree would be these:
1. Measure the proportions with your pencil.
2. Put marks on your page to show the width of the tree. You can make this any size you like as long as you think you can fit three such spaces into the up and down of your page. Then draw an upright line up the middle (lightly!)
3. On your upright line, mark three widths. This will give you the right height for your tree, and its proportions will be correct.

If you practice this, you will soon find that your eye will tell you, without your having to measure, whether something is three times as high as it is wide, for instance, or that the width would fit three times into the height. Proportion is *very* important. Often when a sketch looks wrong, it is because the proportions are not right.

If the object you want to draw is tall, measure the width first.

PROPORTIONS CAN BE PUZZLING

Each pair of rectangles is the same size. Upright lines or horizontal lines make it hard to see the proportions.

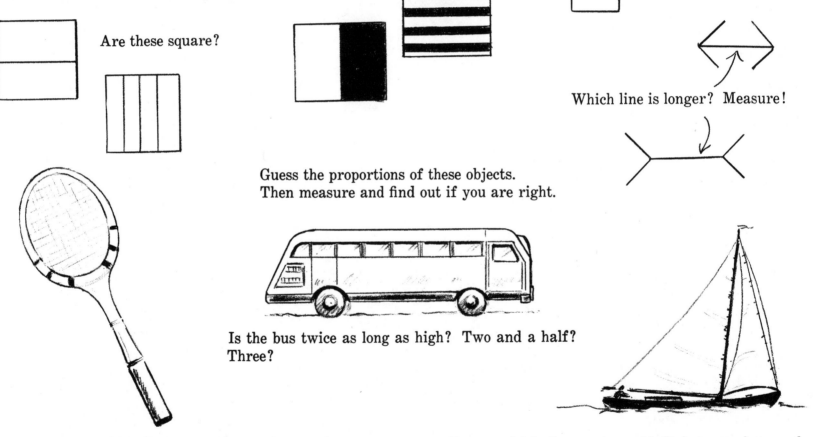

Are these square?

Which line is longer? Measure!

Guess the proportions of these objects.
Then measure and find out if you are right.

Is the bus twice as long as high? Two and a half?
Three?

Is the tennis-racket more than three times as long as it is wide?

Do you think the mast would fit between bow and stern?

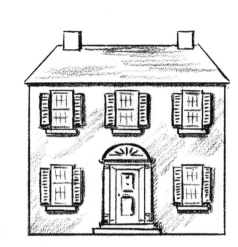

On this page you will find the steps used in draw-
ing three very familiar objects. It would be very
good practice to follow the steps, but make every-
thing *twice as big*. Also *guess* the proportions first,
then measure to see if you are right. Then use your
imagination—decorate the Christmas tree; put
things on the shelves; make the walls of the house
look like brick, or stone, or wood; perhaps put
flowers in front of it.

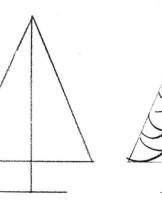

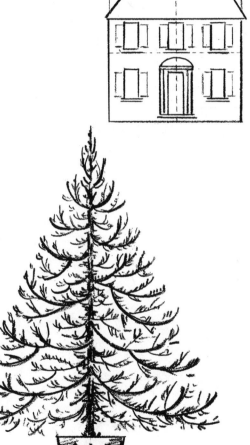

AUTOMOBILES

Now suppose you want to draw really big things, like cars, boats, planes. It is very important to know how big one part is, compared to another part. In other words, you must get the *proportions* right.

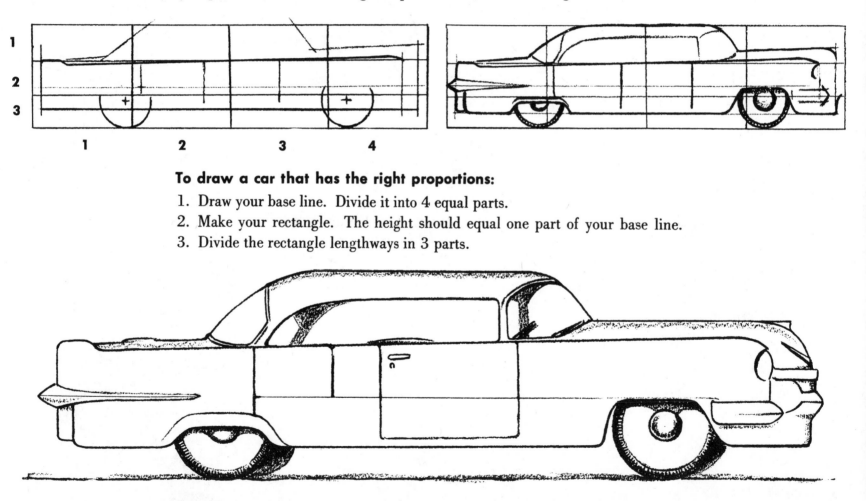

To draw a car that has the right proportions:

1. Draw your base line. Divide it into 4 equal parts.
2. Make your rectangle. The height should equal one part of your base line.
3. Divide the rectangle lengthways in 3 parts.

the Air (Proportions)

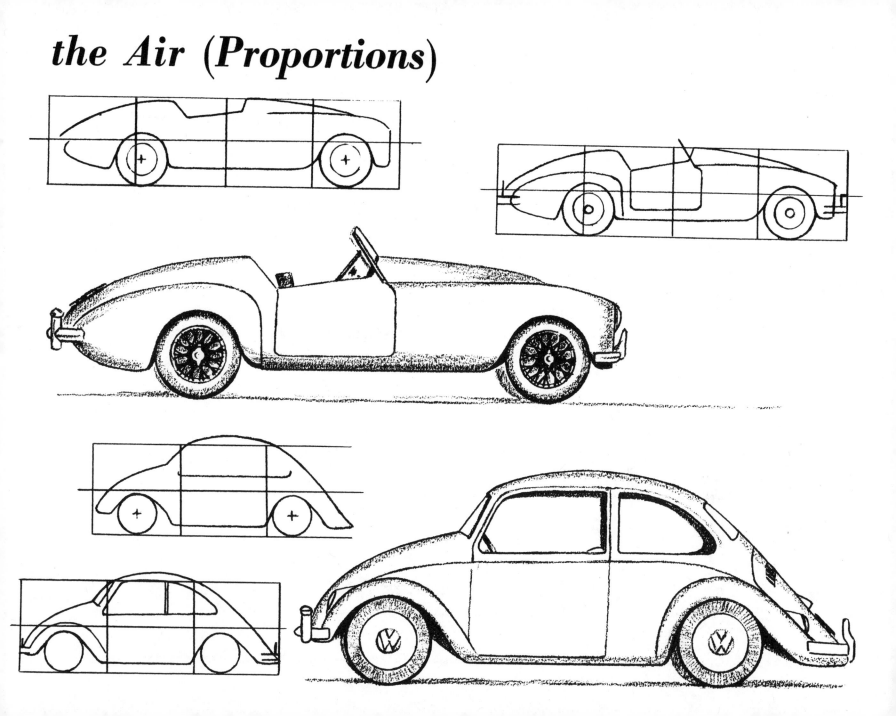

BUS

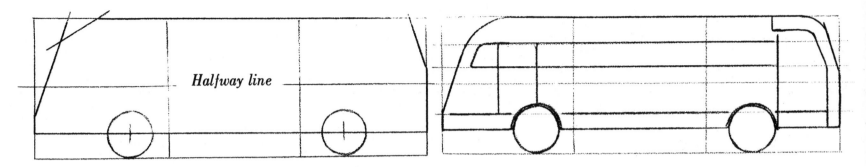

Halfway line

1. Draw a straight line for the ground.

2. Divide it into three equal parts.

3. Make a rectangle three times as long as it is high. Now you have three squares side by side. Draw lightly. You will want to erase these guide lines later.

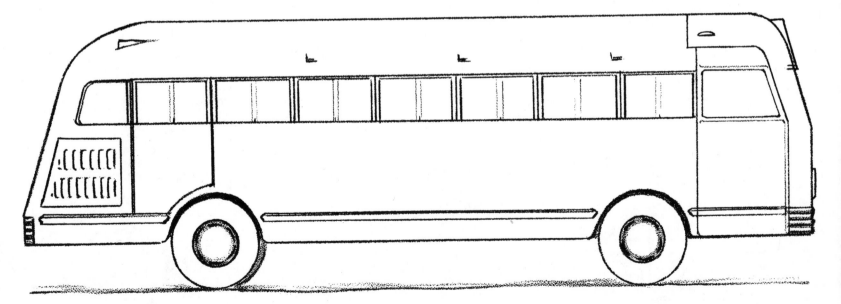

TRUCK

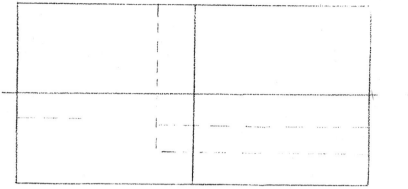

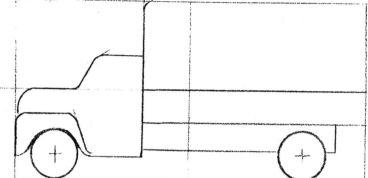

Two squares, divided in half

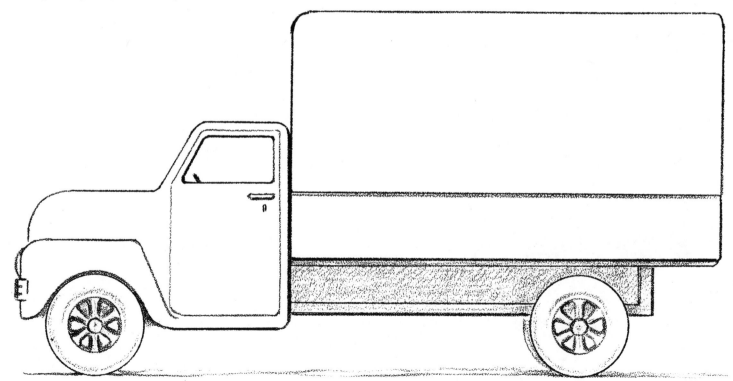

BICYCLE

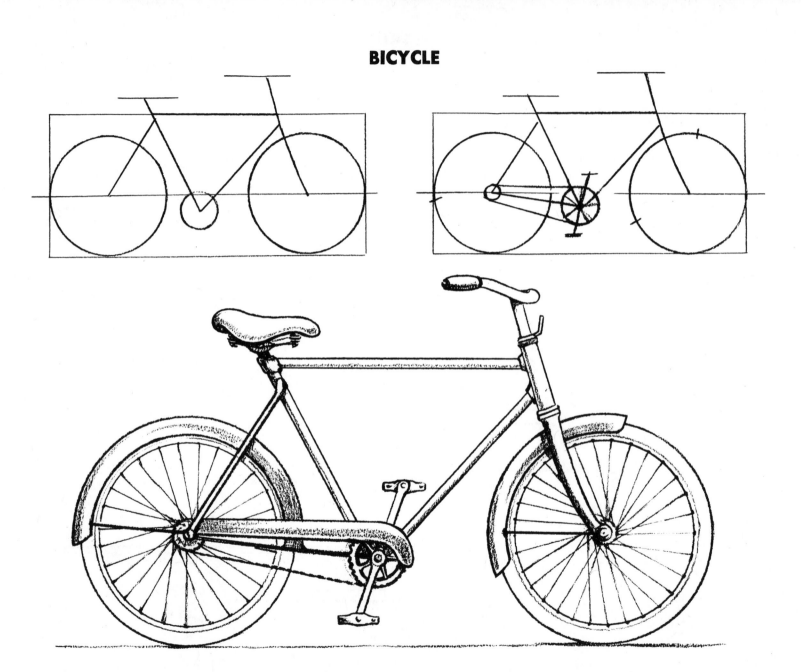

DINGHY

PLANES

Jets

LEARNING TO SEE

3. Construction—how things are made.

A doll's carriage is not very hard to draw, but you might find it difficult to get right unless you look at it very carefully to see how it is put together. Here is a doll's carriage, seen from the side. Ask yourself these questions:

1. What are the basic shapes?
 A rectangle and two circles. (Although there are four wheels you really only see two in this view.)
2. Would the carriage, without the hood and the handle, fit best into a square, or a rectangle wider than it is high? (Measure and find out!)
3. Is the body of the carriage, without the handle, the same depth as the width of a wheel? (See what you think, then measure to be sure.)
4. Look at the wheels. Are they the same size? How are they attached to the carriage?

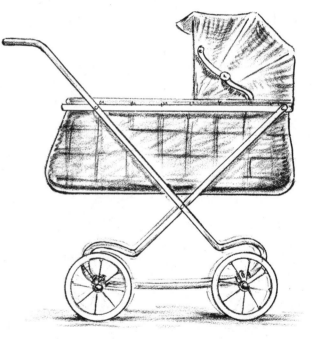

On this page you will find the steps for drawing the doll's carriage. Try it for yourself, making your drawing larger. Draw the basic shapes very lightly so that you can erase these lines later.

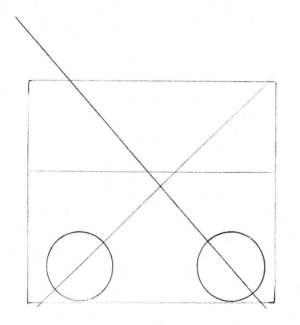

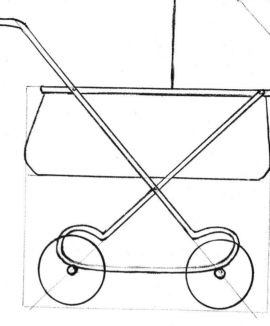

1. Draw the rectangle
2. The diagonal lines
3. The middle horizontal line
4. The circles

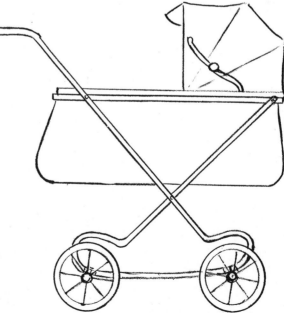

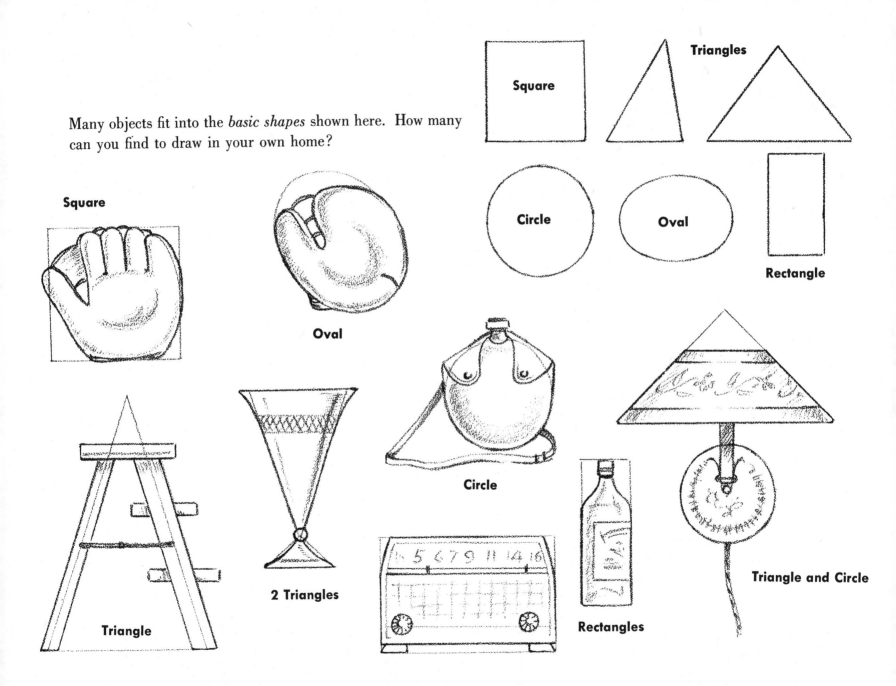

Many objects fit into the *basic shapes* shown here. How many can you find to draw in your own home?

Square

Triangles

Square

Circle

Oval

Rectangle

Oval

Triangle

2 Triangles

Circle

Rectangles

Triangle and Circle

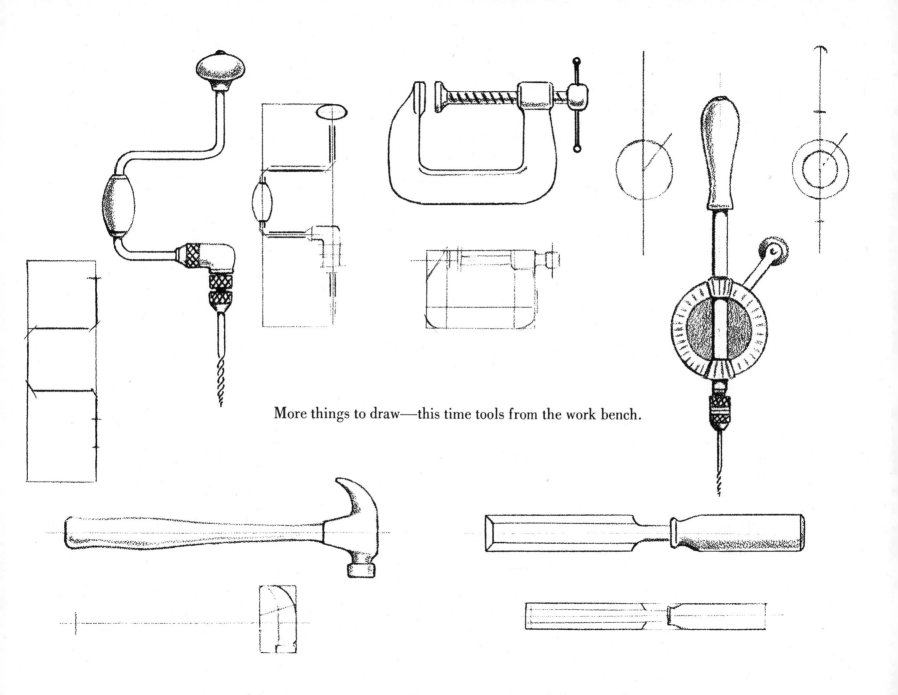

More things to draw—this time tools from the work bench.

Construction—difficult shapes

If you have a difficult shape to draw, first you must try to see how it is put together. For instance, a maple leaf is not an easy shape to draw. But if you look at *the way it is made*, it is much easier. Here is the leaf.

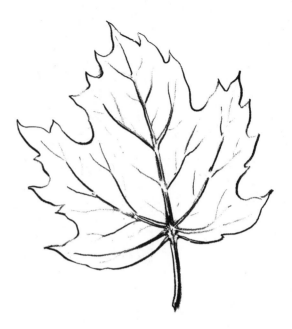

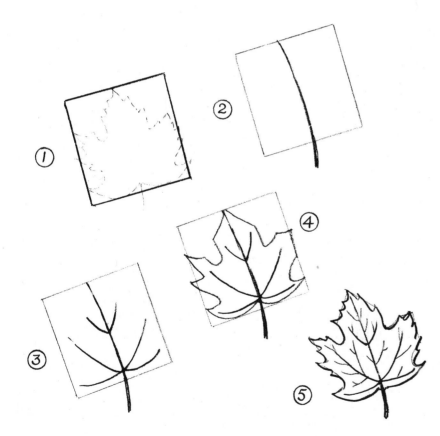

These were the steps in drawing it.
1. Decide what the basic shape is.
2. Look at the stem. See how it continues to the tip of the leaf.
3. Look at the "ribs" of the leaf. Think of the angles where they meet at the stem.
4. Now you can put the big shapes in.
5. Now the details!

Always try to see the big shapes first; leave the details to the last.

FLOWERS

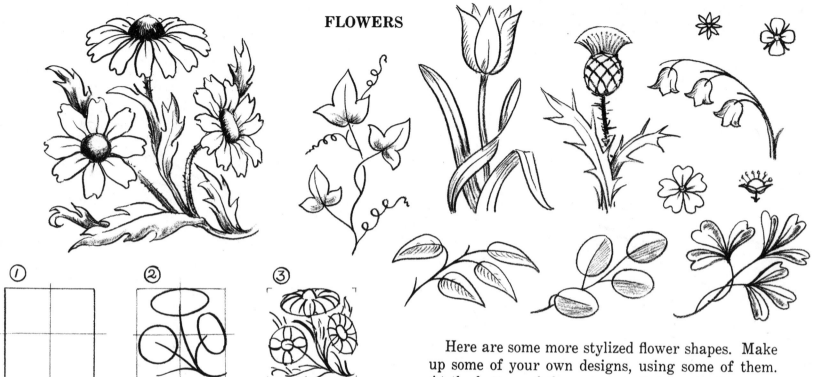

Here are some flowers. These flowers are *stylized* —that is, they are not drawn exactly like real flowers; their shapes have been made ornamental, as if for a design. This design was made to fit into a square. The simple shapes were planned first, then the details were added.

You might try this design. Follow the steps, but make your flowers twice as big.

Notice where there is a little shading; this helps to make parts of the flowers distinct from each other.

Here are some more stylized flower shapes. Make up some of your own designs, using some of them. At the bottom of the page are sketches to show you how you might begin a design for a circle, say, or a triangle.

LINE—the movement in lines

Lines can have motion. For instance, here is a line that flows:

Compare this line with these:

Doesn't the first line seem to be moving?
Sometimes the best way to draw an object is by trying to feel the movement in it. For instance, here is a spray of leaves:

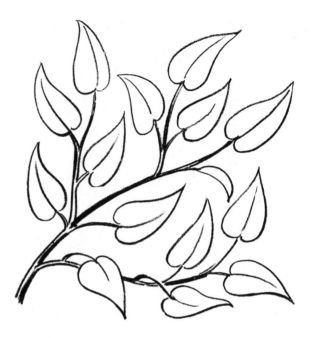

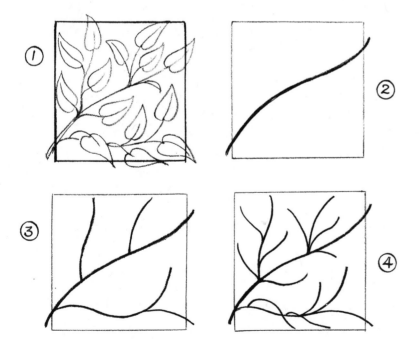

Here are the steps in drawing it.
1) If you imagine it on your page, the whole spray has a basic square shape.
2) Try to draw the main stem. This line *flows*. Try to draw it in one sweep.
3) Now put in the other stems.
4) Next the leaf stems; lastly, the leaves.
Now make a new, different design, but use the same steps with a basic *oval* shape.

Here is a swan. 1) Basic shape?
2) The flow of the line
3) The details

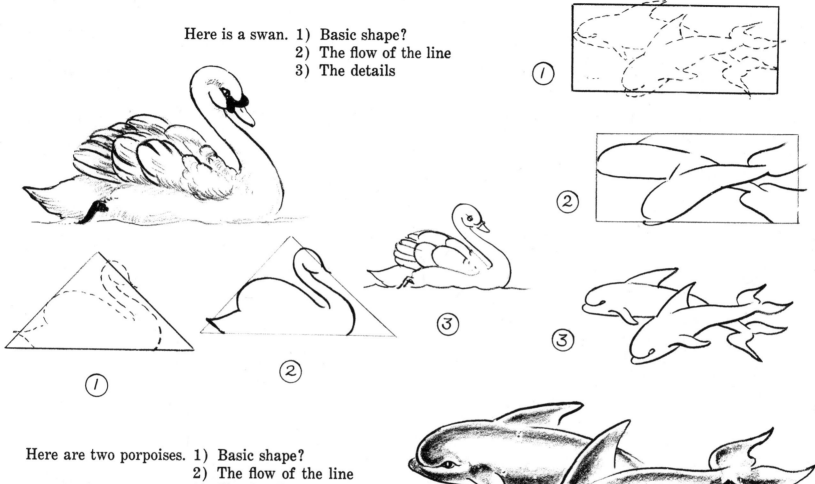

Here are two porpoises. 1) Basic shape?
2) The flow of the line
3) The details
Using the side of your pencil, you can put some
shadow on them, like this. This is called modeling,
and it helps to make their bodies look round, not
flat.

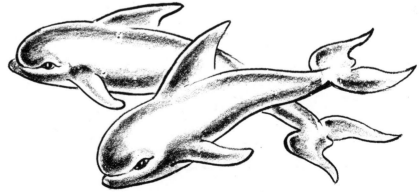

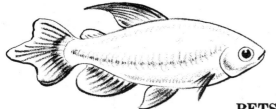

PETS: Fishes

Have you an aquarium? Fishes have wonderful flowing lines. Draw the lines in one sweep if possible. Put in a little modeling!

And don't forget some bubbles and some weeds. You might make some of the weeds come in front of the fishes. If you have different fishes, try drawing them. What are their basic shapes?

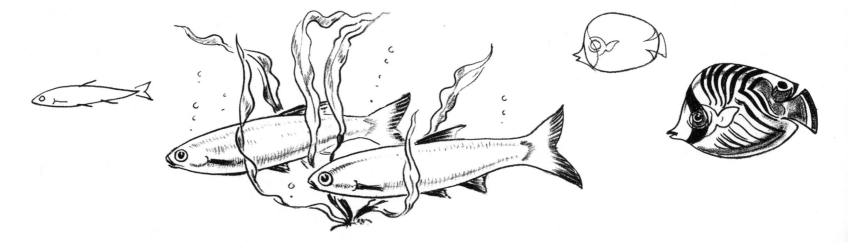

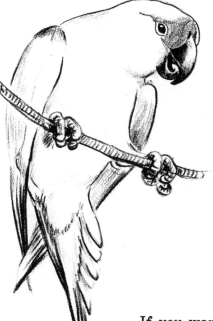

Birds

Birds, like fishes, have long smooth lines; their basic shapes are sometimes harder to see. Be sure you do not make their heads too small for their bodies.

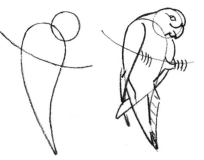

If you want to put the bird in a cage, make the wires *very* light across it. You could make some of the lines broken, too—it will give a good effect.

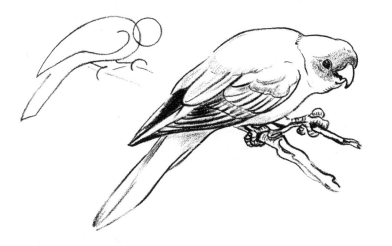

You might try drawing these dogs. Before you begin, study the proportions. Look at the shapes and see which are the *most important lines*. Then very lightly sketch the framework. Then, still drawing lightly, put in the large simplified shapes so that when you get to the details you have something to build on.

Dogs

When you draw animals, you need to know how they are put together! Here is a sketch of a dog's framework—inside him—showing the different parts of it. Look at any dog and see if you can find where the bones are joined together.

Here is a simplified sketch of the framework, to show the joints. See what happens when the dog walks or runs. Its legs bend, and its backbone curves.

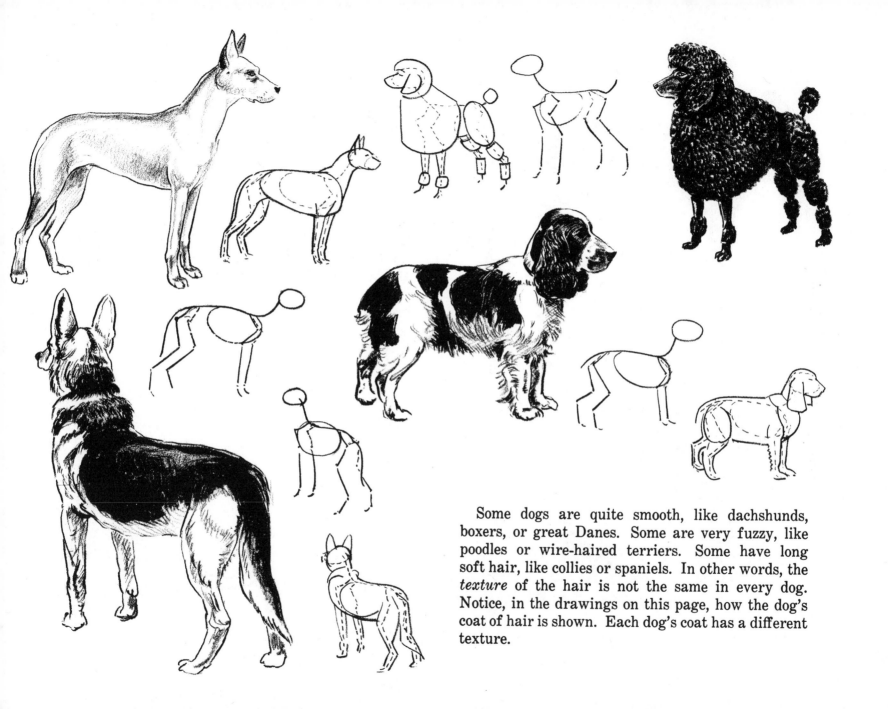

Some dogs are quite smooth, like dachshunds, boxers, or great Danes. Some are very fuzzy, like poodles or wire-haired terriers. Some have long soft hair, like collies or spaniels. In other words, the *texture* of the hair is not the same in every dog. Notice, in the drawings on this page, how the dog's coat of hair is shown. Each dog's coat has a different texture.

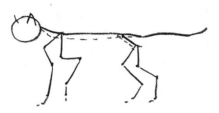

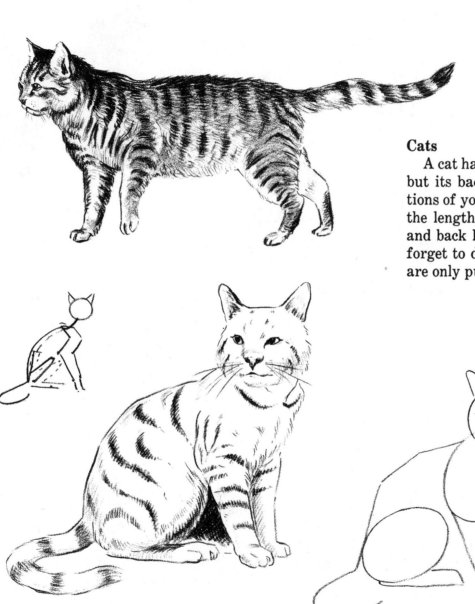

Cats

A cat has very much the same framework as a dog, but its back is usually longer. Look at the proportions of your cat and think about the size of its head, the length of its neck, the difference between front and back legs, etc. When you begin to sketch, don't forget to draw the simple shapes very lightly—they are only put in to help you!

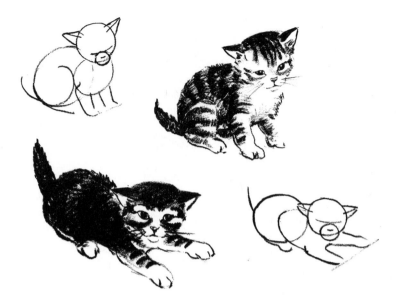

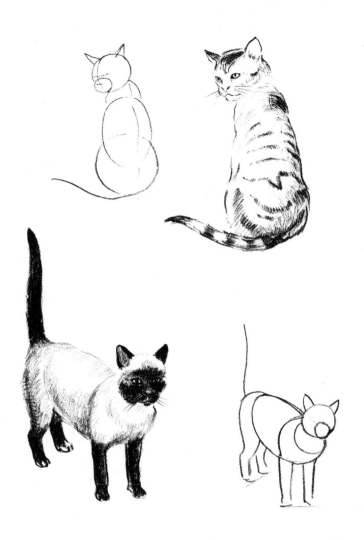

A kitten's head is very big for its body.

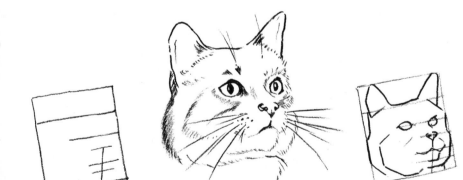

Don't forget your cat's whiskers—draw them last, with quick strokes, starting at the base, not the tip.

Of course you must try to draw your own pets from life!

HORSE

Start with a big square. See how much of the square is taken up by the body and by the legs.

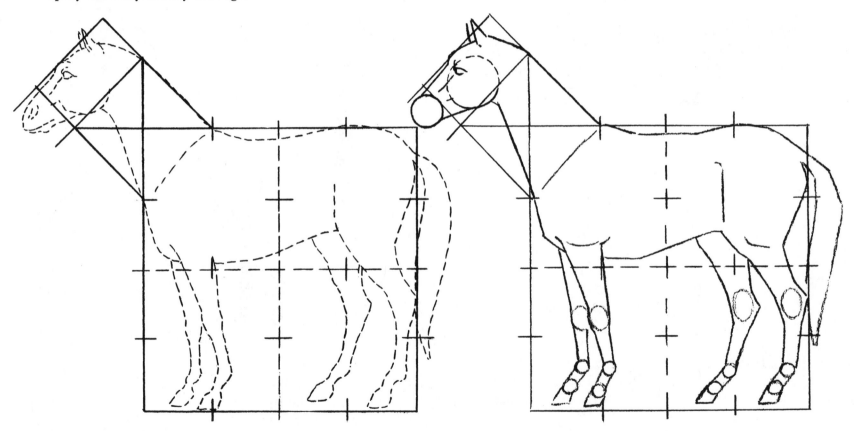

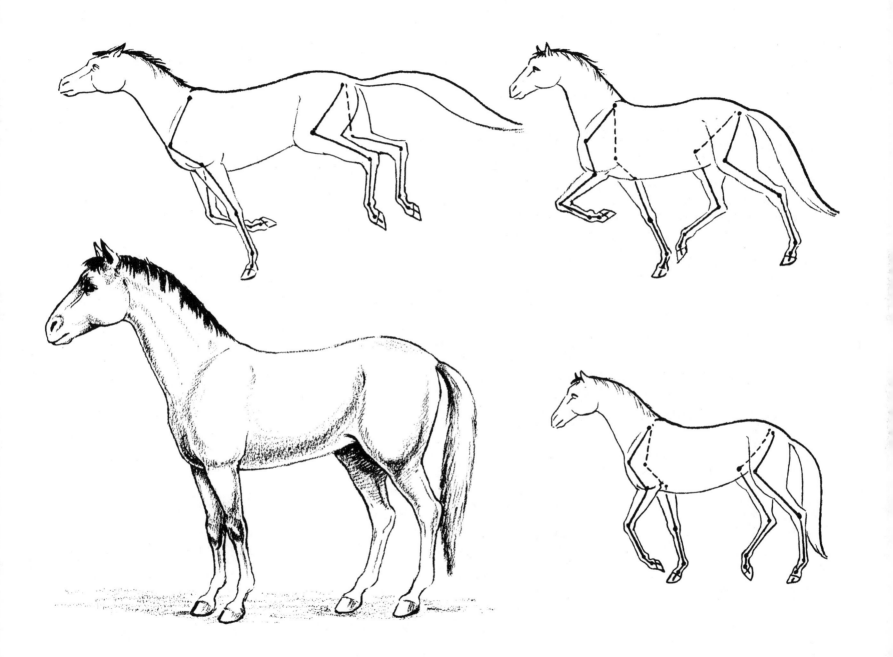

If you want to draw a horse really well, you must understand how its framework is put together. Here is a drawing of the bones inside a horse, showing how they are joined together. The simplified sketches show what happens to the framework of bones when the horse walks, trots or gallops.

The line from the horse's head to its tail is also drawn in; note how it lengthens and flattens out, the faster the horse is moving.

Here is a drawing of a horse. The diagram marked "A" will help you to learn its proportions. See how the body and legs will fit into a square. The diagonal lines help to show the angle of the head and neck.

Diagram "B" shows you how to build up your drawing of the horse.

1. Draw the square framework—lightly! You can make your square any size. (All five of the small squares are the same size.)
2. Lightly block in the outline of the horse.
3. Erase the framework.
4. Work up the variations in the outline and details.

Repeat this drawing many times, making your square frameworks different sizes. Then you can try it without the squares. Finally, try drawing the horse facing the other way. This is not as easy as you may think.

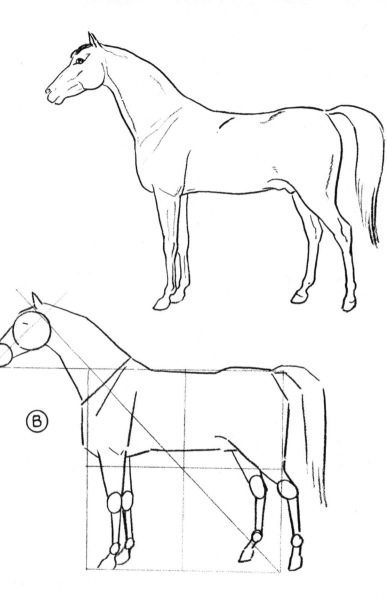

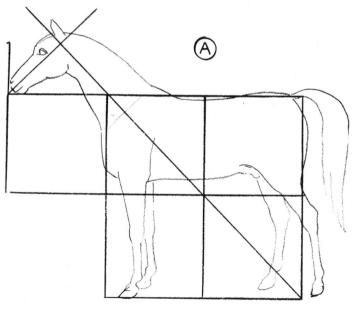

Ⓐ

Ⓑ

Notice how very stretched out this jumper is.

Foals have quite different proportions from grown
horses. Their legs are very long, and the texture of
their coats is rough and shaggy, not smooth and
glossy.

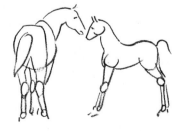

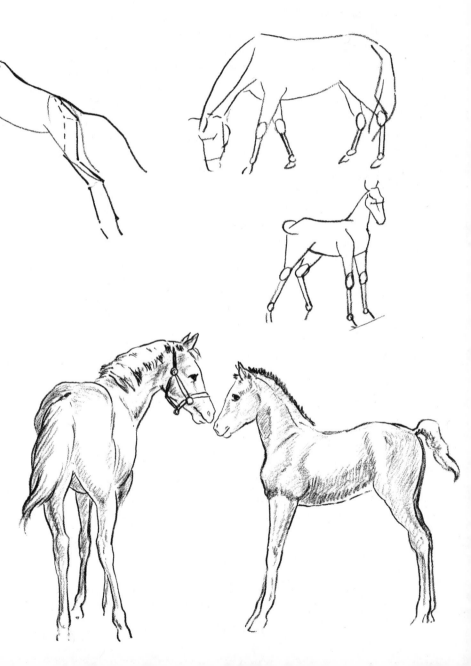

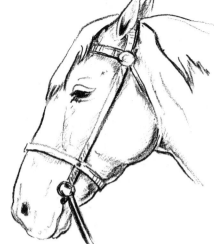
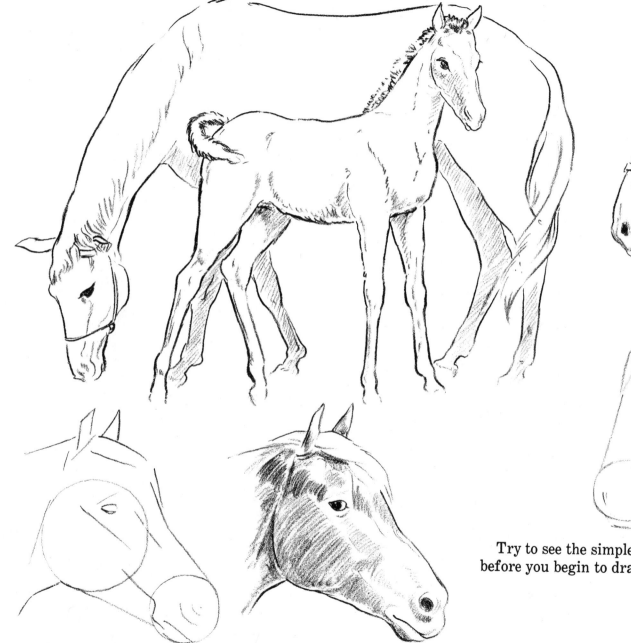

Try to see the simple basic shape in a horse's head before you begin to draw.

Things near to you look larger than those further away. If you draw two cowboys in the same picture, anyone looking at it knows that the smaller one is further away. This is a rule of *perspective*. What is wrong with the picture at right?

Down (Perspective)

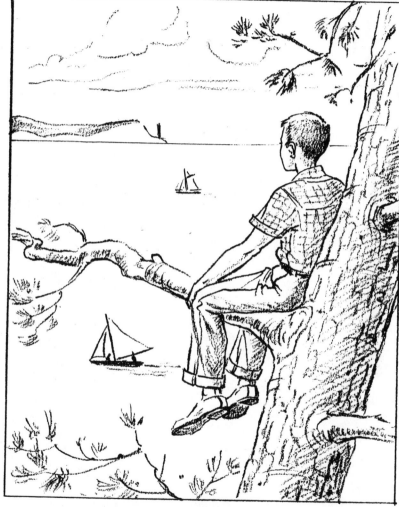

The horizon is always on a level with your eye. If you lie down, it is lowered. If you climb a tree, it is raised. This is another rule of *perspective*. When you want to give a picture distance, you must decide where your horizon is.

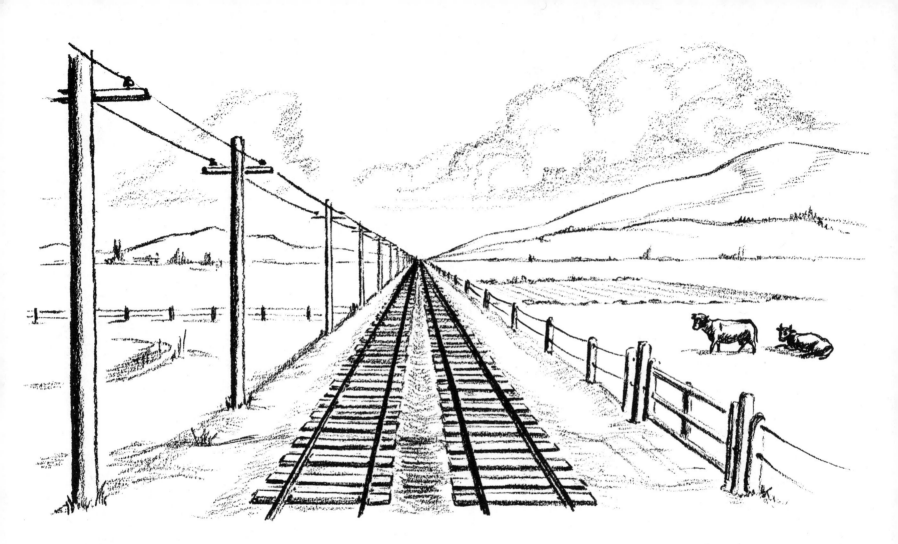

Find the horizon. This may surprise you, yet it is true that:

1. The tracks are the same distance from each other all down the line. But as they go away from us they seem to get closer together until they disappear *on the horizon.*

2. The telegraph poles are all the same height, but they seem to become smaller and closer together until they disappear *on the horizon.*

3. A line drawn along the tops of the poles, which are *above* your eye level, slopes *down* to the horizon.

4. A line drawn along the base of the poles, *below* your eye level, slopes *up* to the horizon.

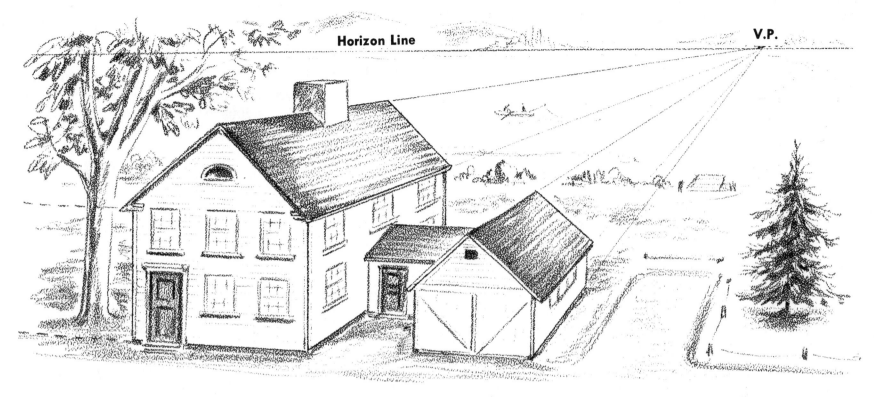

Here is a drawing with a *high* horizon line. Draw this line
first, then mark your base lines and vanishing point.

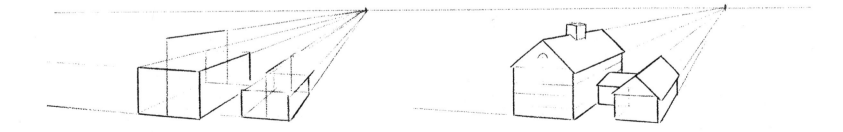

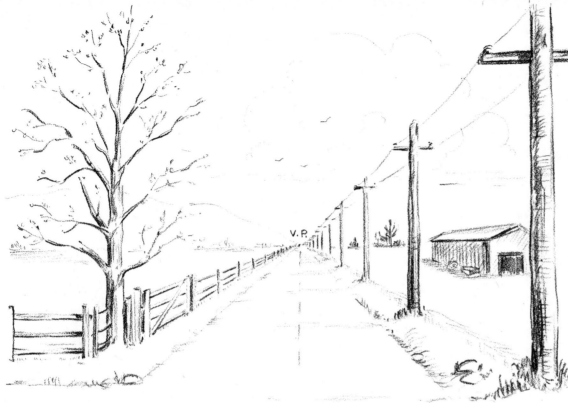

SPRING

These next pages will tell you more about perspective and will help you to draw houses and trees.

The horizon in this drawing is marked for you. Imagine you are standing in the middle of the road. Notice how the road seems to get narrower and narrower until the sides meet at a *vanishing point on the horizon*. The telegraph poles get smaller and smaller until they disappear—*on the horizon*.

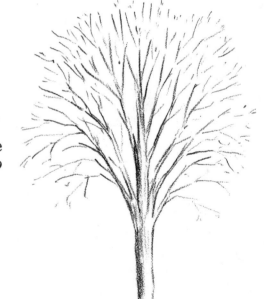

A line drawn along the top of the telegraph poles, *above* your eye level, slopes *down* to the horizon.

A line drawn along the base of the poles, *below* your eye level, slopes *up* to the horizon.

Step 1 Start with the horizon line

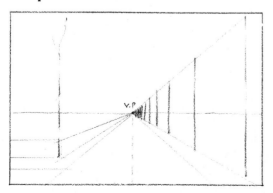

Step 2

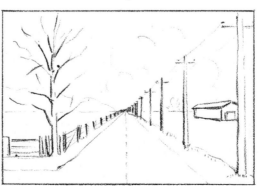

Spring is a good time to look at the framework of trees—the way the branches grow out from the trunk.

The tree in the picture is an oak. Compare it with this elm tree.

SUMMER

In this picture the house is turned at an angle. This means that if you continue the base lines, they would meet the horizon at *two* vanishing points.

Look at the steps for drawing this picture and try it for yourself. The horizon is medium—not high, not low.

Summertime is fine for looking at the different shapes of trees—their silhouettes. Notice the very different silhouettes of the two trees beyond the house. The nearer one is a Lombardy poplar; the farther one is a maple. The tree nearest you is an elm. Notice that by making the branches and leaves come *in front of* the house, the house is thus *farther away* than the tree.

The corner of a frame house usually looks like this:

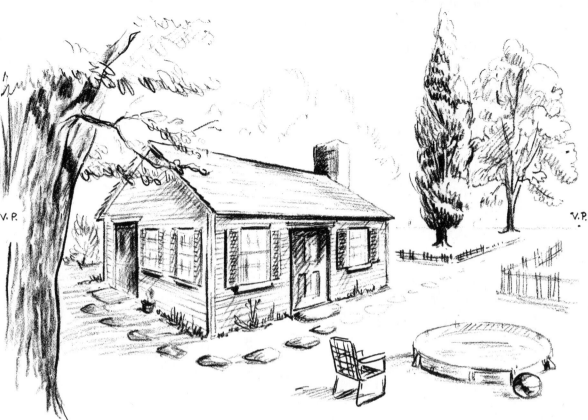

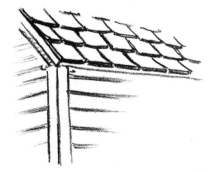

Notice that a roof has thickness! It is not a sheet of paper.

Step 1 Step 2

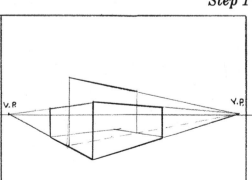

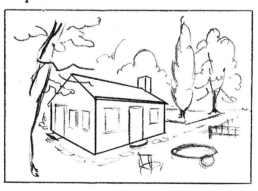

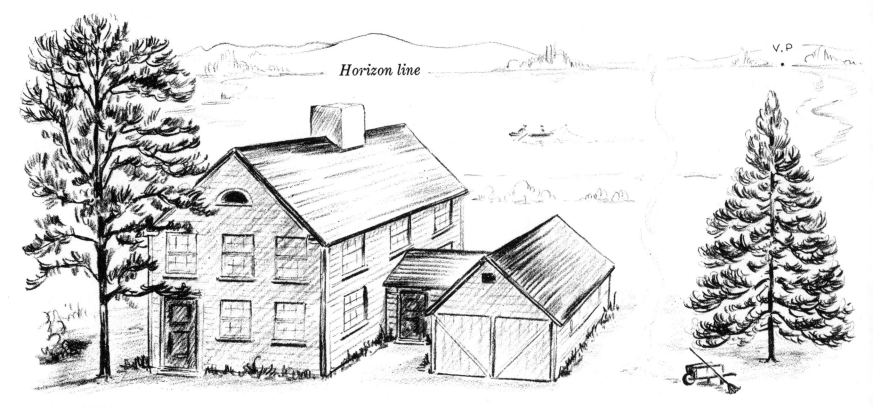

Horizon line

V.P

AUTUMN

In this picture the horizon is *high* and the house is turned only at a very slight angle. Because of this small angle you cannot actually put the V.P. on the left of the horizon *in* the picture, since it is away outside. But the front base line of the house does go *up* towards the horizon very slightly.

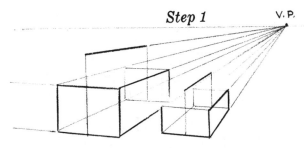

Step 1

V.P.

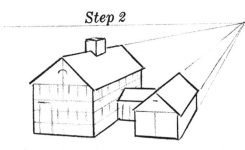

Step 2

Notice that far-off objects such as trees and hills are drawn much more lightly than the house and trees near you: This helps to give a feeling of distance.

The tree on the left is a pine. The tree on the right is a spruce.

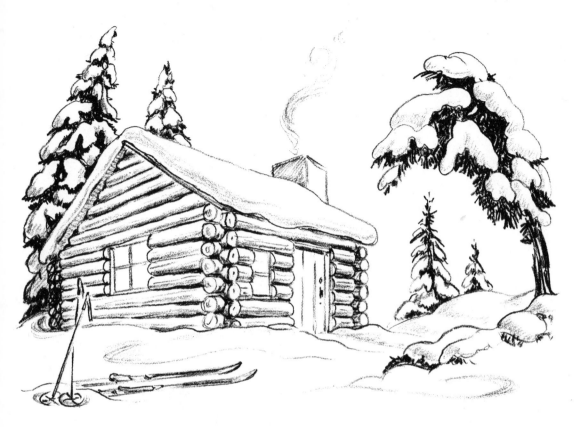

WINTER

In this sketch the horizon is *low*. To get the perspective of the log cabin you must imagine the vanishing points outside the picture this time.

Notice the smooth round shapes of the snow on the roof and on the tree.

In a real log cabin the walls are made like this, with notches cut in the logs so that they fit together.

The chinks between the logs are filled in with moss and wood shavings and mud or plaster.

Step 1

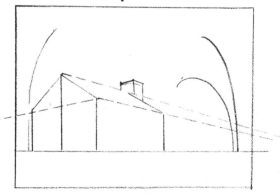

Step 2

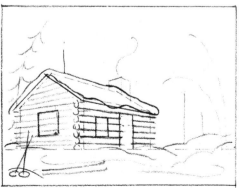

Try some experiments with perspective. Put a cardboard box, such as a shoe box, on a table, with the side parallel to the edge. Stand directly in front of it and then try raising and lowering your eye level to see what happens to the lines.

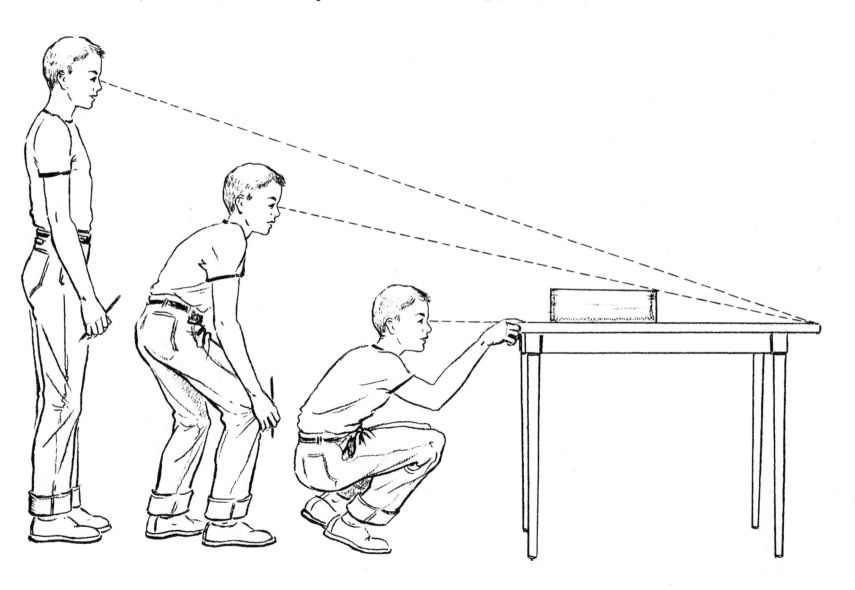

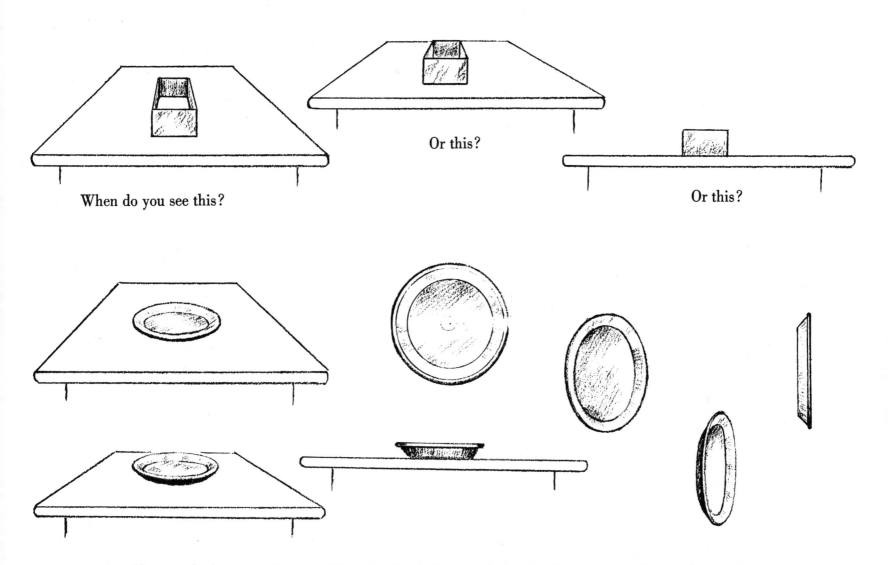

When do you see this?

Or this?

Or this?

Now try the box experiments with a pie plate. Also stand the pie plate on edge like a wheel and notice what happens when you turn it. Can you see it change from a circle to an ellipse to a line?

People are all around you. And they are fun to draw. Why not try some?

These sketches will show you some differences in proportion between children and adults. Notice how many times the head will fit into the height. Notice also the different lengths of legs in the figures.

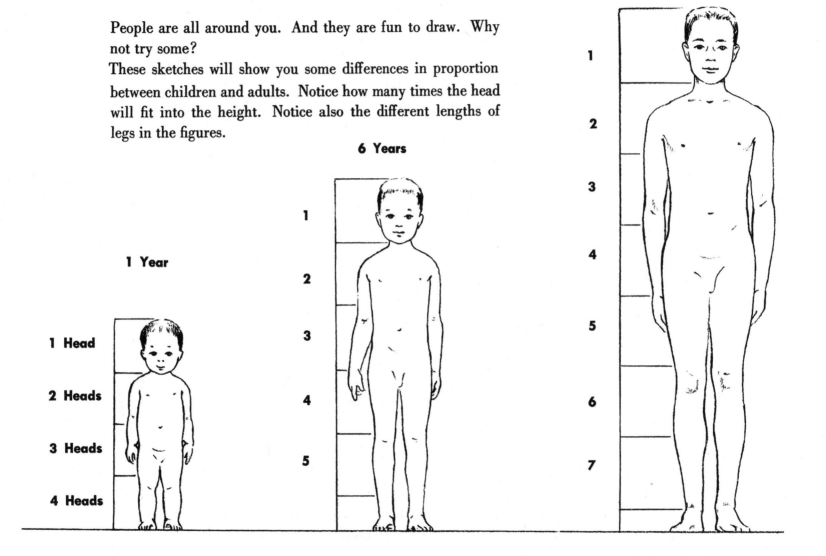

12 Years

6 Years

1 Year

1 Head

2 Heads

3 Heads

4 Heads

DRAWING PEOPLE

Study the proportions of these girls.

See how many times a head fits into the height of each girl.

Measure a head and see how it fits into a *width*.

Notice how short the baby's legs are.

Where is the halfway point between the ground and the top of the head of the 8 year old?

Of the 16 year old? Measure!

Were you right?

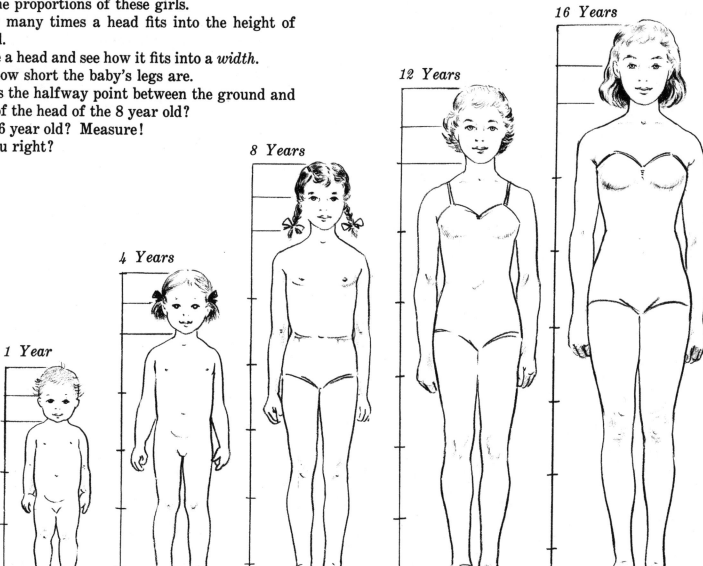

16 Years

12 Years

8 Years

4 Years

1 Year

1 Head

2 Heads

3 Heads

4 Heads

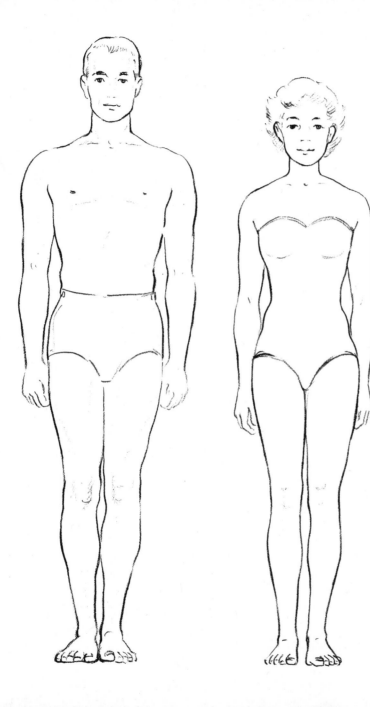

Boy, Man, Woman, Girl

These sketches are for comparison—to show the differences in the build of the body of an adult man or woman, young boy and girl.

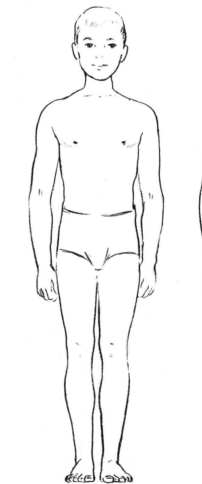

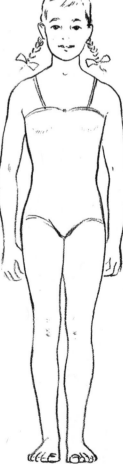

On the left is a drawing of the skeleton bones inside a man. Next to it is a "stick figure," to show you how you can draw the framework of the body very simply. You should practice drawing stick figures until you feel sure of the right proportions.

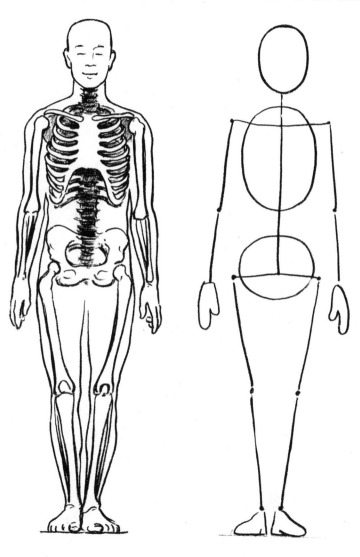

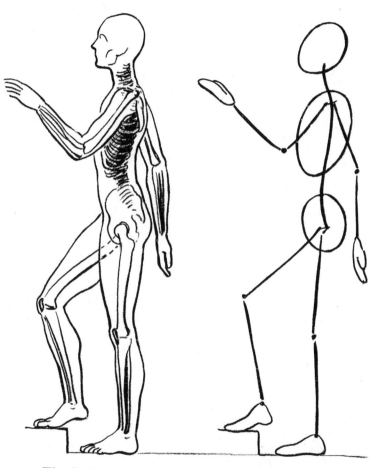

The body can bend only at the joints. The spine can curve because it is made of many bones strung together like a necklace.

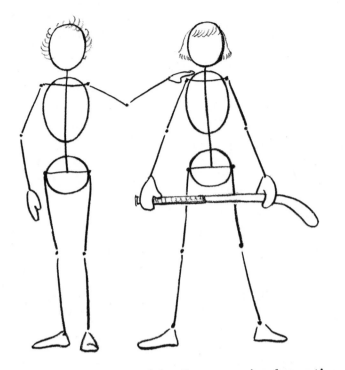 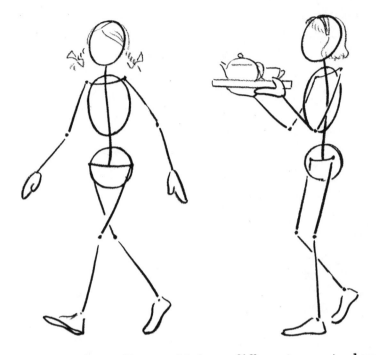

Here are some stick figures—simple action sketches. They will help to remind you of the correct proportions. Try to think up different ones to draw —whenever possible, take the pose yourself and *feel* it.

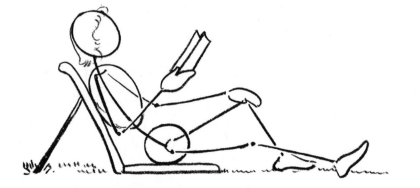 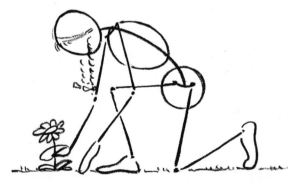

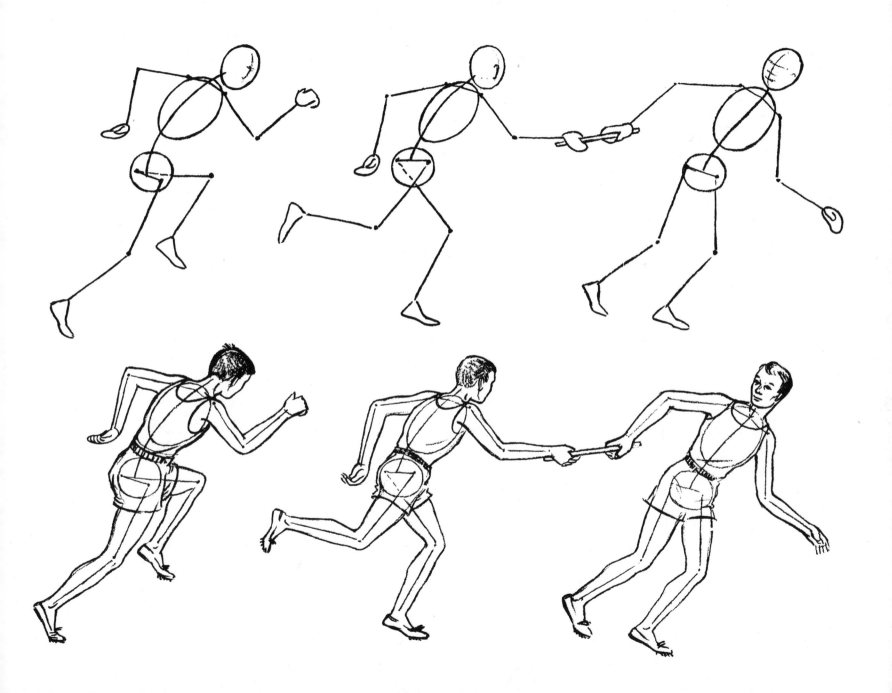

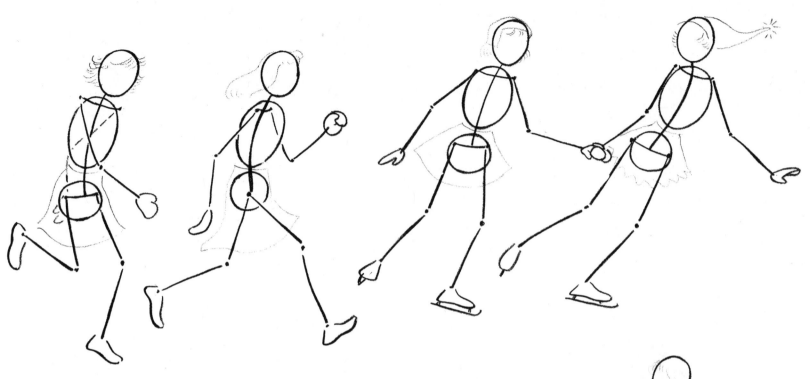

Notice the balance of arms and legs. When you run, right arm goes forward with left leg, left arm with right leg.

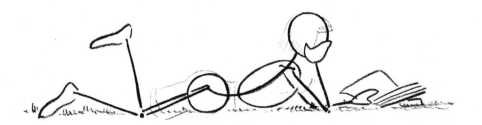

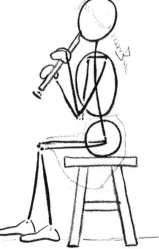

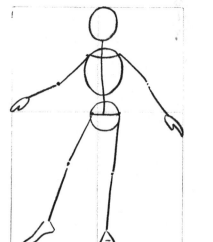
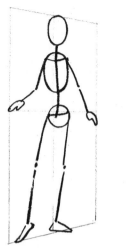
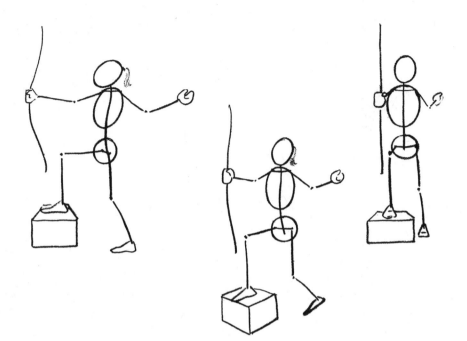

Perspective in figure drawing is called fore-shortening. Study the sketches on this page. In the bottom series notice how the upper part of the body, as it is tipped further away from you, is much smaller in proportion to the lower part—that is, it is foreshortened.

Begin to think of filling out your stick figures. You might use tubes for the straight parts and balls for the joints.

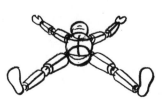
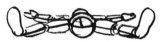

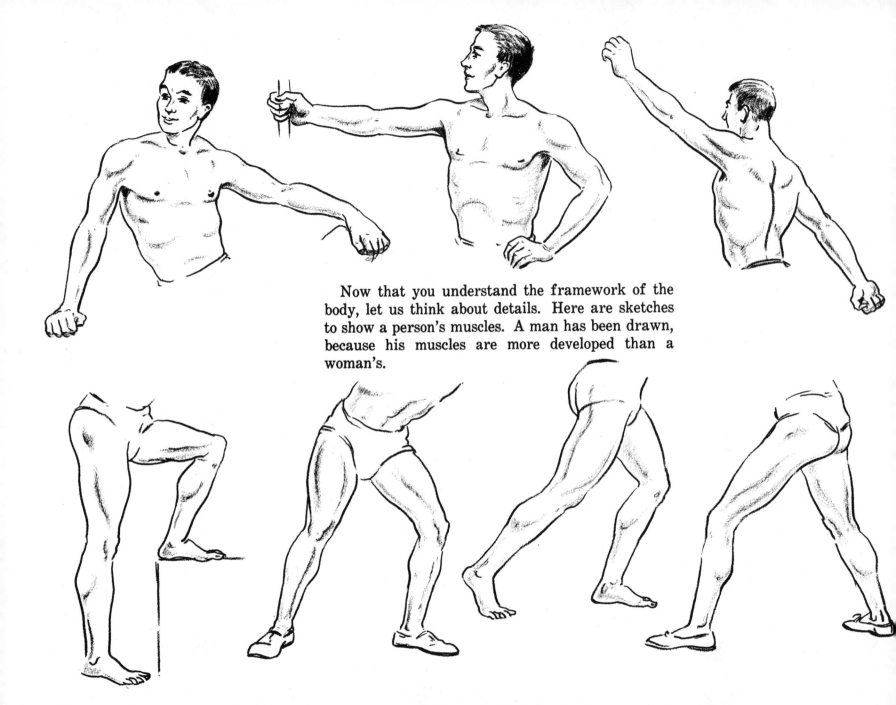

Now that you understand the framework of the body, let us think about details. Here are sketches to show a person's muscles. A man has been drawn, because his muscles are more developed than a woman's.

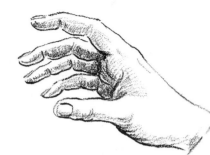
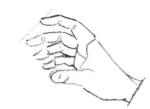

Hands and Feet

Hands and feet are not easy to draw. Draw your own hand. Perhaps you can persuade someone to sit still so that you could try drawing her feet. If you want to draw a hand holding something like a ball, for example, draw the ball first and fit the hand around it.

HEADS

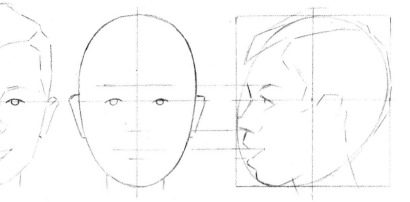

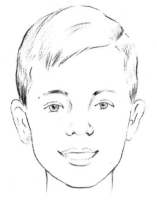

The eyes lie halfway between the chin and the top of the head. When you want to draw a head at an angle, it is a good idea to imagine it in a box. See what happens when it is tilted.

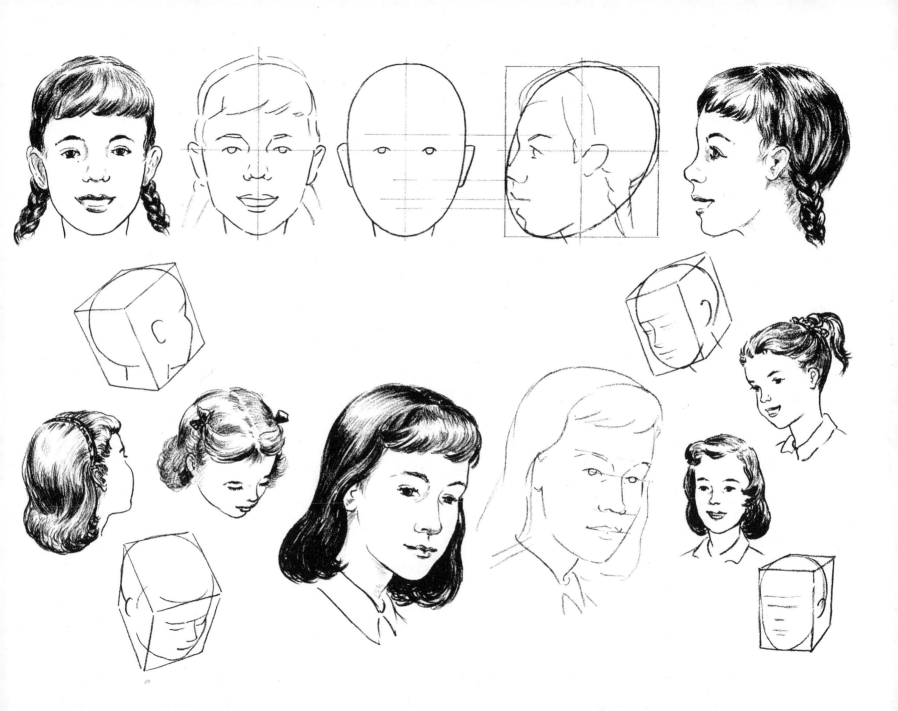

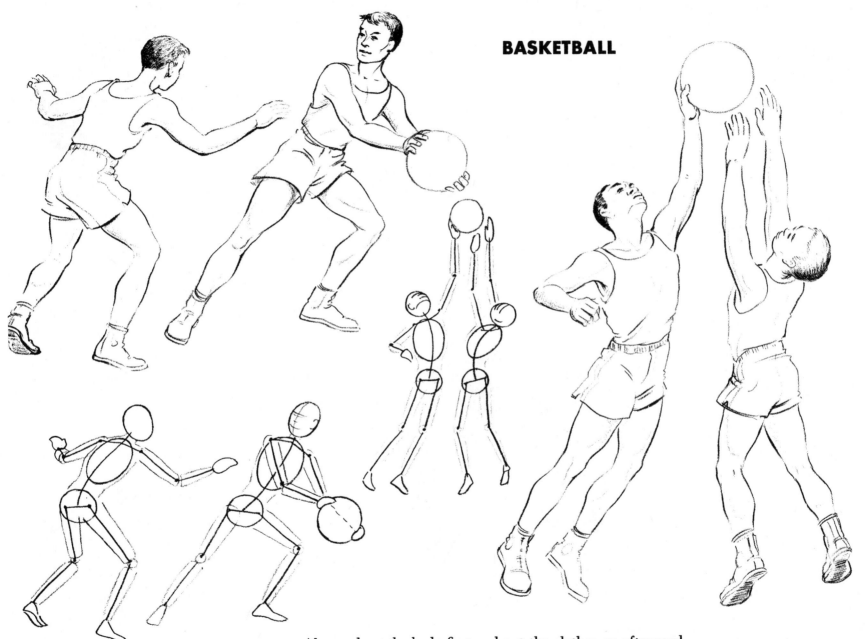

BASKETBALL

Always draw the body first and put the clothes on afterward.

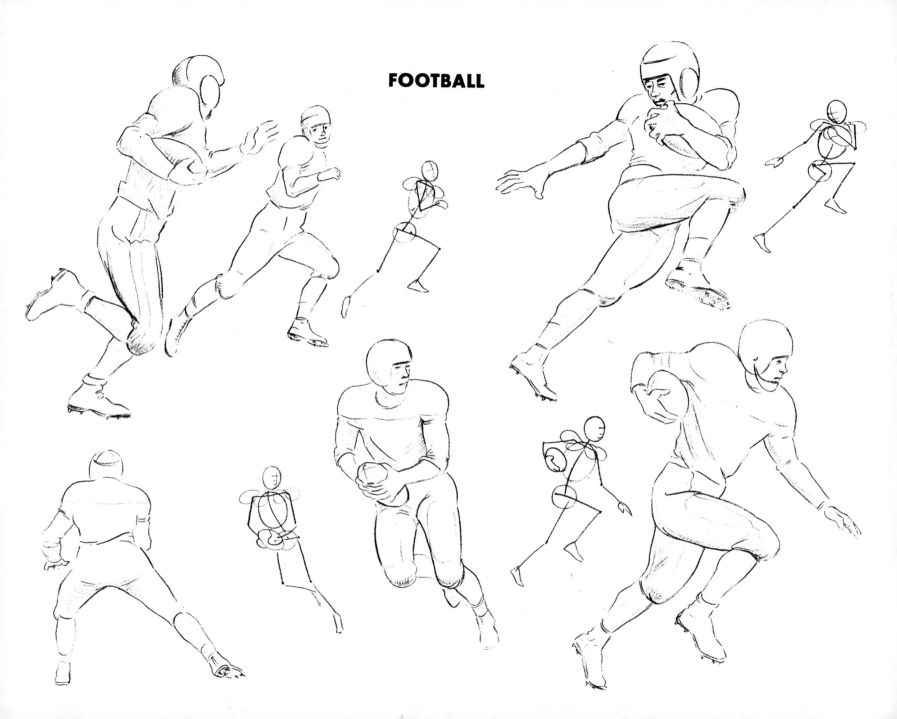

FOOTBALL

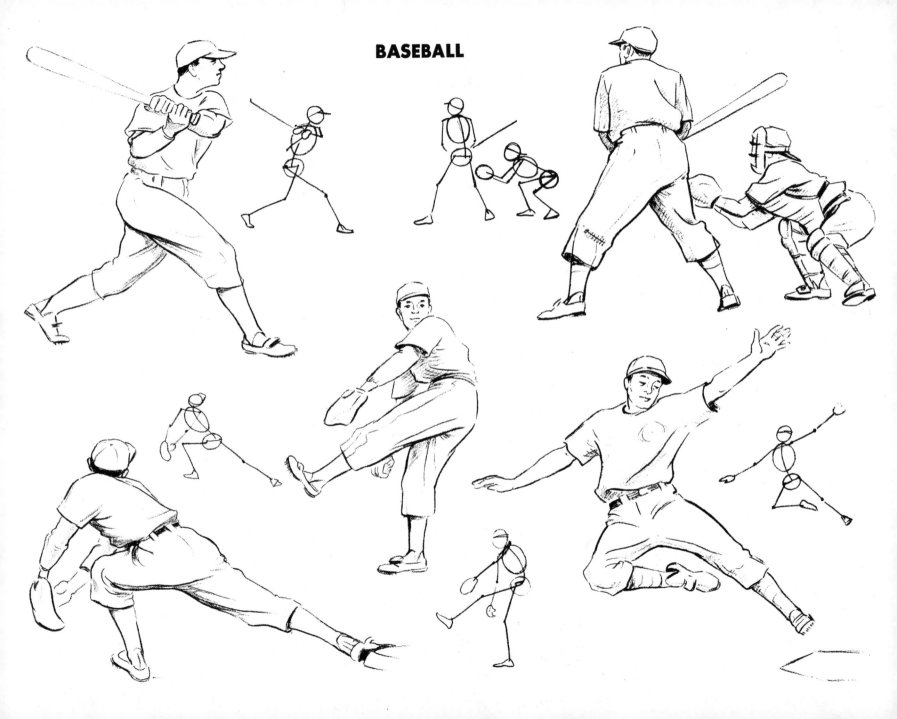

BASEBALL

BALLET

Ballet is a very stylized form of dance. Here are some sketches of characteristic poses for you to study. Try to make your own also, always starting with a stick figure to help yourself understand the action.

RODEO

Decide where your figures will be placed, and how big each one will be. Remember the rules
of *perspective* and *proportion*.

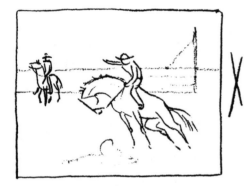 X

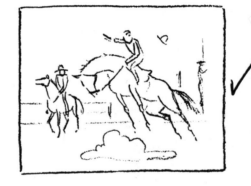 ✓

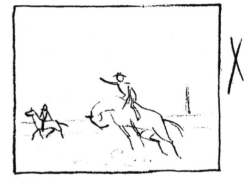 X

Sketch the bucking horse first. Then add his rider.

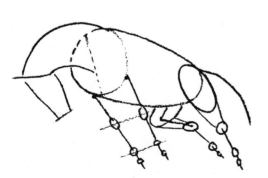

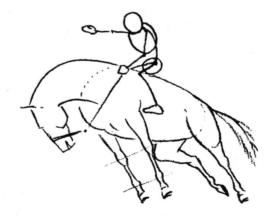

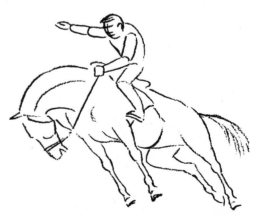

Pictures

1. "See" the action of the main figure.

2. Decide on your shadows.

3. Add other details.

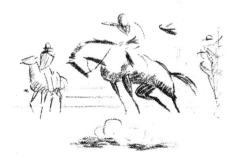

Concentrate your dark shadows on your most important figure. Keep your less important figures very simple, and more sketchy. Use the flat side of your pencil to make strokes for the shadows.

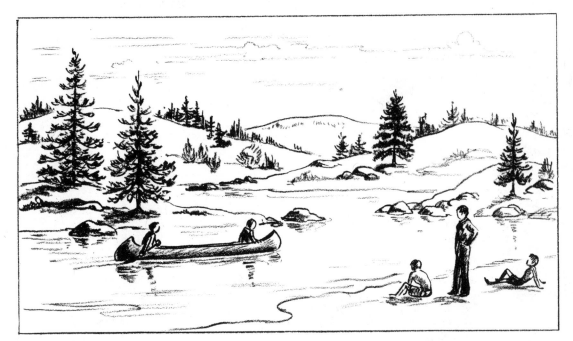

Here is a sketch that expresses *quietness*.

Horizontal lines and upright lines are *static*; that is, they do not have movement.

Notice how the reflections in the water, the clouds in the sky, echo the same quiet line of the lake shore and the trees. Compare this calm scene with the one on the next page.

Step 1

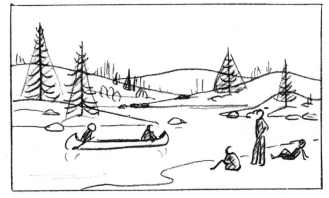

Step 2

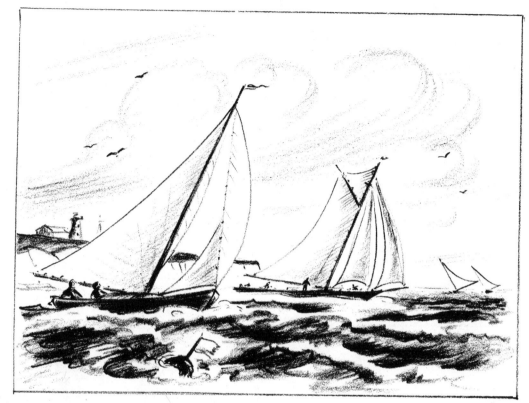

Windy day

Diagonal lines and flowing lines in the water all help to give a feeling of movement in this sketch. Notice also the sweep of the clouds behind the boats.

Compare the waves with the calm surface of the lake on the opposite page. You can use the flat of your pencil for the waves—like this:

Step 1

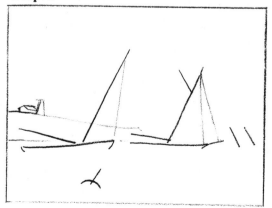

Step 2

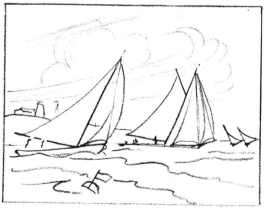

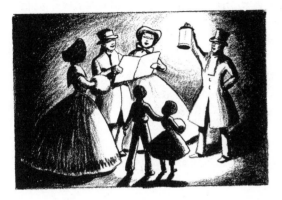

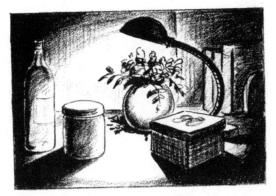

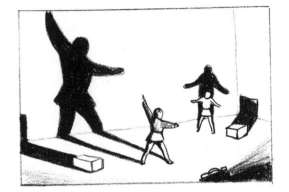

Light and Shadow

When light falls on any object, it makes a shadow. These sketches show how shadows are cast from a single source of light, such as a lantern, a reading lamp, a spotlight. If you draw a picture of an outdoor scene, the sun or the moon is your source of light.

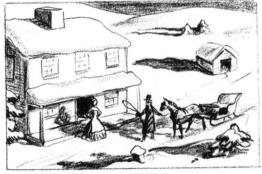

Late afternoon shadows are long.

Midday shadows are short.

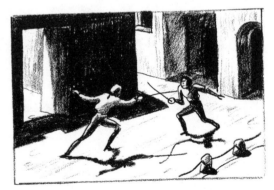

Moonlight gives strong contrast.

LANDING ON THE MOON

Try several small rough sketches of your idea first. Which interests you most?

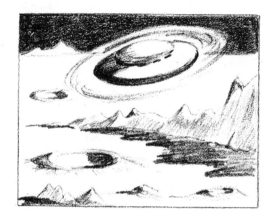

Flying saucer and landscape?

Humans on the moon?

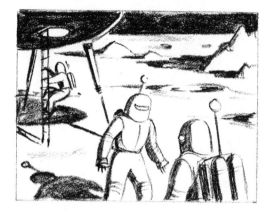

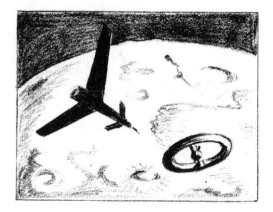

Space Travel?

Choose the one you like best and work it up into a complete picture.

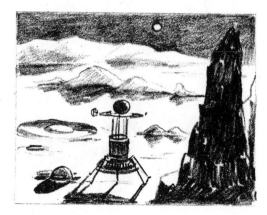

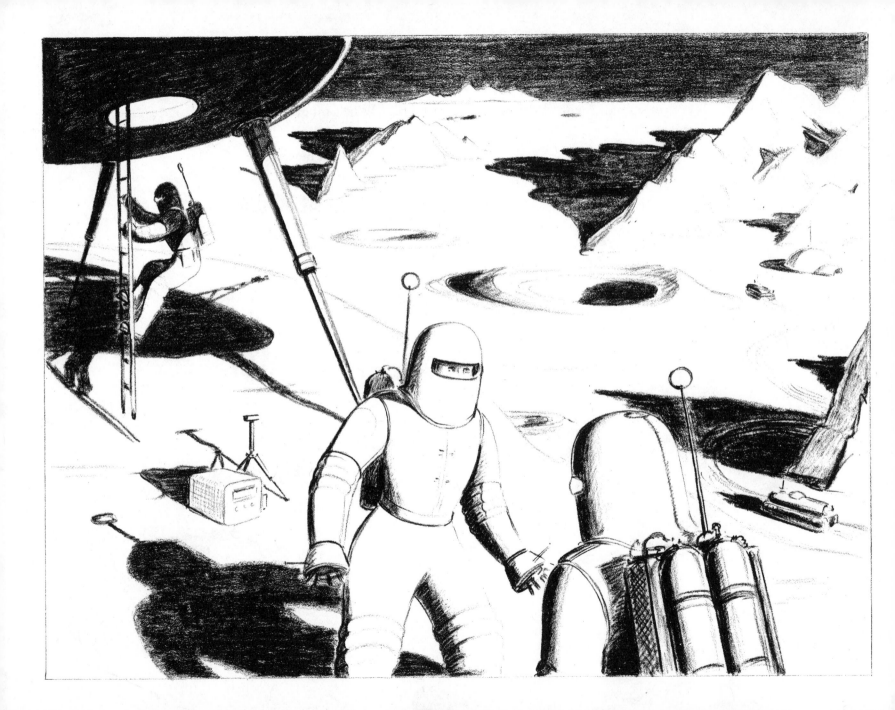